Sister Wendy
on the Art of
CHRISTMAS

Sister Wendy Beckett

Franciscan
MEDIA
Cincinnati, Ohio

Copyright © Redemptorist Publications 2008. First published as a series of *The Sunday Bulletin* during Advent and Christmas 2007–2008. First published in book form: November 2008.
The credits on page iv constitute an extension of this copyright page.

Cover and book design by Mark Sullivan. Sister Wendy image © Photoshot.
Cover image *The Adoration of the Magi*, 1623-1624, Abraham Bloemart,
copyright © Musee des Beaux-Arts, Grenoble, France.

LIBRARY OF CONGRESS CATALOGING-IN-PUBLICATION DATA
Beckett, Wendy.
Sister Wendy on the art of Christmas / Sister Wendy Beckett.
pages cm
Summary: "Imagine going on a tour of a world-class art museum with a talented and insightful curator. But instead of just focusing on the history, technique, and cultural significance of each piece, you have the opportunity to reflect on the spiritual aspects of the works, examining their religious significance and concentrating on the transcendental meaning conveyed by the artist. This is what you'll find in this exquisitely produced book. Sister Wendy writes with the deft hand of one who is formed in spirituality, art, and critical thinking. Her imagery is lush, creating a landscape where the sacred and profane live in comfortable coexistence through the medium of painting. For spiritual seekers and lovers of art, this book will offer a unique journey into the experiential nature of a well-rounded faith"— Provided by publisher.
ISBN 978-1-61636-695-7 (pbk.)
1. Jesus Christ—Art. 2. Christmas in art. 3. Jesus Christ—Meditations. I. Title.
N8050.B35 2013
704.9'4853—dc23
2013018832

ISBN 978-1-61636-695-7

Published by Franciscan Media
28 W. Liberty St.
Cincinnati, OH 45202
www.FranciscanMedia.org

Printed in the United States.
Printed on acid-free paper.
13 14 15 16 17 5 4 3 2 1

CONTENTS

Picture Credits

INTRODUCTION

We are all born and each of us will die: Those are the two certainties of life. In between these certainties God has given us the gift of time so that we may grow into the fullness of what we are meant to be. This fullness is different for each of us, but the ways in which it is achieved are the same.

Since God made us in his own image and we know what that image is through the historical actuality of Jesus, each person's fullness is an attainment of a likeness to our Blessed Lord. When we are as God wants us to be, we will have within us what St. Paul calls "the mind of Christ." We learn this "mind" most of all by prayer, silent prayer, and the wonder of sacramental prayer. We learn it through reading the Scriptures where God reveals himself in his Son, and, complimentary to that, we come close to Our Blessed Lord in the books written by those who have understood the Scriptures.

Yet prayer, worship, and reading are only a part of our day (though, literally speaking, everything is or should be prayer). One of the most neglected truths is that we learn to become like Jesus through the actual process of living. God is giving himself to us all the time; but all too often we do not see it. He gives himself in human relations, in nature, in literature, in music, in art. This book is an attempt to show how he gives himself to us in art.

Artists have an awareness of something greater than themselves, as do most of us. The crucial difference is that they can make this awareness visible. Art draws us out of our own smallness into what one could call a vision for which there are no words. We experience it through the artist's skill, but to reach this experience we have to look very closely at what the artist has done.

In many of the works I have chosen, what the artist puts before us flows from a scriptural narrative or some other aspect of faith. We cannot encompass the liberating power of the vision unless we understand the essential elements of the story. Looking closely and letting the work reveal itself to us is a paradigm of all looking. How are we to seek God if we do not look?

Once we have learned the deep joy of looking at art—which can also be an alarming challenge, when we see things in ourselves that we would rather not see—we are emboldened in our looking at the life in which we are embedded.

One of the verses of Scripture that moves me most deeply is the great cry with which Jesus died on the cross: "It is consummated." He

had fulfilled completely the will of his Father. He had never neglected or passed by that holy will, displaying itself in the most ordinary of circumstances.

None of us can come even near this wonder of "consummation." We have missed so much, not out of malice but through sheer ignorance and lack of interest. We do not take enough trouble, to paraphrase St. John Vianney. God was there but we did not see him.

When you look at the pictures in this book, really look, opening your heart to take in what is there before you, you are not only responding to a particular work of art, you are practicing the habit of openness to the beauty of God as he illuminates every moment of your every day. Understood correctly, appreciating and understanding art is a profound form of prayer. It changes us. Or rather, it will change us if we allow the Holy Spirit to utter within us the total yes of Jesus to the Father.

—*Sister Wendy*

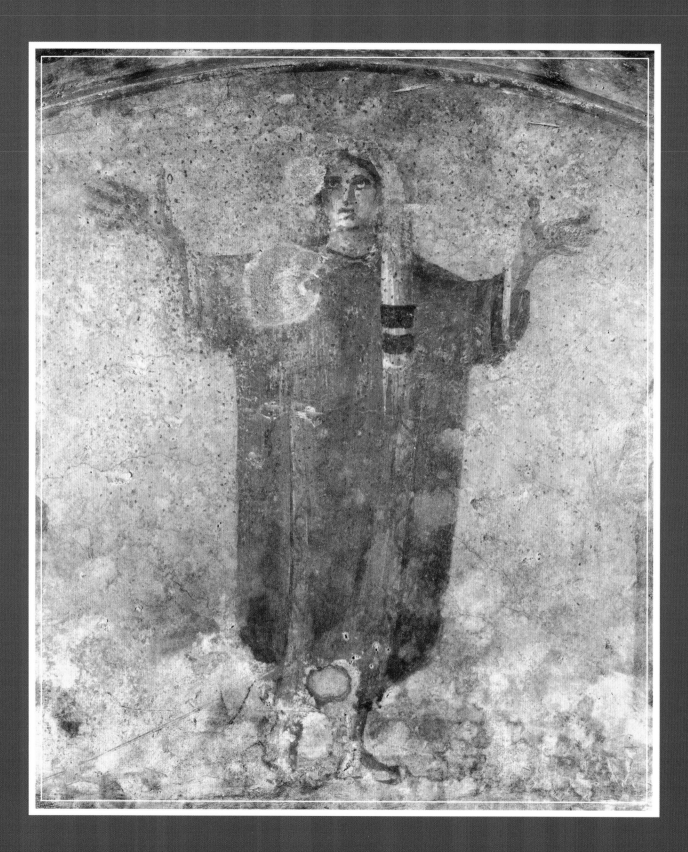

ADVENT

Orante, detail from a fresco in the Catacomb of Priscilla, Rome, mid–third century

For centuries—for millennia—the whole world was in a state of advent: it was waiting. Until the Lord revealed himself to Abraham, our ancestors did not know for what or for whom they were waiting. But every thinking being knew (and still does) that our present state is not right. Injustice, violence, misery: This is not how it is meant to be, and all our instincts cry out against it.

The revelation to the chosen people made the focus of our longing clear. Humankind was waiting for a Savior. It was an open-ended wait, with no time limit. We, who relive this longing each year in the four short weeks of the Advent season, have the privilege of knowing precisely when the wait will end and the coming (the advent) become manifest. Our Blessed Lady herself did not know. She prayed in trust but without any private awareness of how near salvation was. She only knew when the angel appeared and the great countdown began.

The figure from the catacombs makes visible that ardent and trustful desire. A woman standing with outspread arms is called an *Orante*— "one who prays." This Orante, clumsily painted, wears a prayer shawl and plants her feet firmly apart. Arms open, she pleads with her God to send the Messiah.

The painting dates from the third century A.D. Jesus has come. But has he been received? Advent is not an imaginative replay of those desperate centuries without a Jesus. It acknowledges that Jesus has come, fully. But have I received that fullness? The woman yearns to enter the kingdom that Jesus came to bring. The kingdom is there, but do we live in it? Do we not wait and yearn as truly as those who lived before Our Lord?

The Orante, being a woman, inevitably brings to mind the one who undid the waiting, Our Blessed Lady. She indeed lives totally in the presence of her son, but through her prayers she seeks to draw in her other children, you and me. For us, Advent is the time when the Church asks us to look seriously at how real the incarnation is to us. How does Christ's coming affect the way we live? It is a praying time, when we are called to take even just a few minutes to think about the reality of Jesus, so passionately clear to this third-century figure, and pray to long for him as she does.

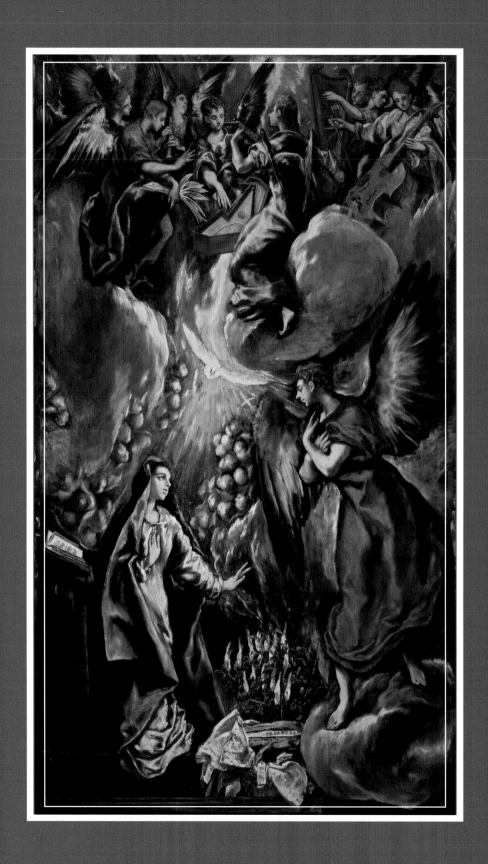

ANNUNCIATION

Annunciation, 1576, El Greco
Museo del Prado, Madrid

When Mary said "Fiat!" to the angel, the worldwide, indeterminate waiting of humanity ended, and the personal, precise waiting of the Virgin herself began. God had breached the impossible barrier between divinity and humanity. The Son of God had become incarnate and was, now, a tiny baby beginning the nine months of his own advent, as he and his mother waited for his birth.

That nativity, which we call Christmas, is a mystery beyond all understanding. All that matters is to believe it. Yet this unique event that would change all human life happened very quietly. In a small house, in a small town, in a small country, the angel Gabriel asked a question of a young woman. Even those in the house next door would not have known what was happening. Perhaps even Joseph in his carpenter's shed had no idea that Mary had received a message of any kind.

El Greco wants to show that this worldly insignificance and quietness exists only on one level. In truth, on the high heavenly level, the annunciation aroused the most intense of jubilations. We know that the Bethlehem skies were alive with music when Jesus was born. El Greco depicts the Nazareth skies as being just as lyrical when Jesus was conceived. The angels pray grandly and rapturously. They, too, cannot understand the incarnation, but they know absolutely that this is a triumph of God's goodness. In this long, thin picture, we feel that the musicians may well extend indefinitely on either side. Heaven is in a state of joy.

The artist is too sophisticated to attempt to show the Father. There is no majestic ancient with a beard. God is represented with a burst of brilliant light, a radiance spilling down from the heart of the music, and holding within its brightness the pure outspread wings of the Holy

Spirit. Now, at last, the Spirit will again brood upon the face of the deep and overshadow with God's love the Virgin, who offers all she is. Jesus is grace visible. Mary, the conduit of that grace, is immersed in white flame and seraphic attendants, like heavenly snowflakes. Gabriel folds his hands. His part is done. Mary opens hers; her part is just beginning.

There is a connection, surely, between the silence of Mary and the overwhelming jubilation of heaven. When we are quiet, steadying our mind, looking at the things that matter, the Lord can give himself to us. Mary is his greatest joy, unimaginable though it is to us. Whenever we look toward God, toward that mystery his Son will reveal, he is always first looking at us. Advent urges us to be still and let heaven rejoice.

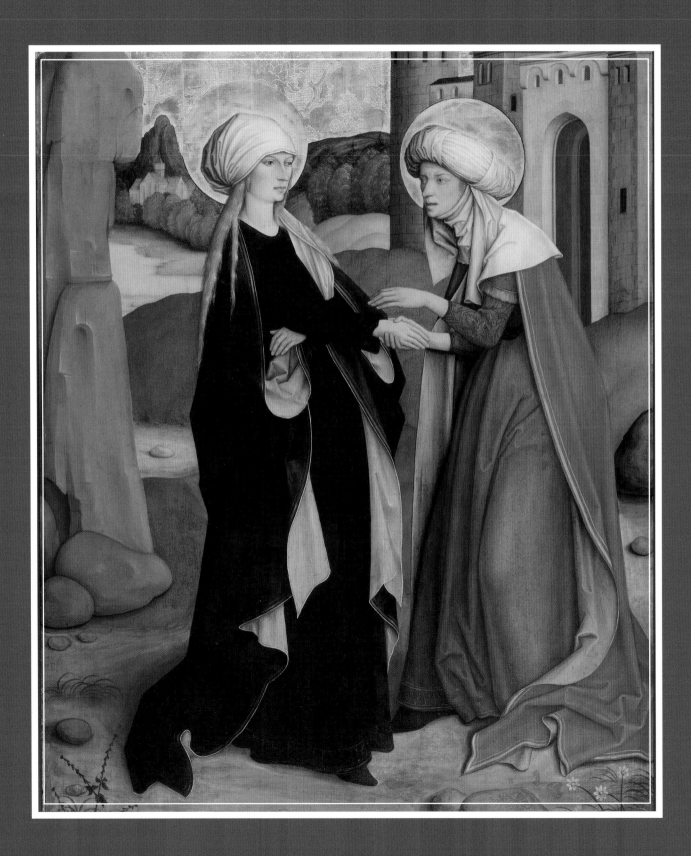

VISITATION

Visitation panel, c. 1500, Master of the Pfullendorf Altarpiece
Städel Museum, Frankfurt

If Our Lady is the presiding figure of Advent, drawing us into her own holy waiting for the birth of Christ, accompanying her is St. John the Baptist. So integral is he to this season that he is even seen as part of the annunciation. The angel explicitly adds to his message that Mary's cousin, Elizabeth, has in her old age conceived a son and is already in her sixth month. This was an "impossible" pregnancy, because Elizabeth was barren, but nothing is impossible with God.

When she had fully taken in the wonder that had happened with her virginal body, the unimaginable closeness now of her Lord and God, Mary's mind must have turned to that distant and elderly cousin away there in the hill country and married to a temple priest. One doubts that they had met, and Mary would have known that Elizabeth had no lack of eager assistance in her longed-for childbearing. Yet how she must have longed to be with her. This was the sole other person to whom she could reveal what had happened.

The two miracles were of a different order of being. One, not wholly against nature (late pregnancy is not wholly impossible), heralded the forerunner, he who would prepare the way. The other, a natural impossibility, heralded the Messiah, for whom the world longed. Yet there was a connection, and Mary set off to visit Elizabeth. This lovely picture, by an artist known only by his work of the Pfullendorf altarpiece, of which this is a panel, shows that first encounter.

It is too solemn, too profound a meeting for either woman to show joy. Elizabeth is stiff with wonder, her eyes marveling, her hands reaching out with infinite reverence to her blessed cousin. "Blessed among women," her lips are open to acclaim. She bends in homage. Mary holds one hand protectively over her womb. Never again will she feel both hands are free. Contact with Jesus, whether in protection or dependence, is now her life's course.

Elizabeth has come out of a city, leaving behind its sheltering walls. She stands vulnerable and alone to receive her God. Mary has long since left the city. Behind her are the rocks over which she has traveled to contact Elizabeth. Behind Elizabeth the way is closed: John the Baptist is the last of the prophets. But behind Mary the world opens out into meadow, tree and mountain, with an anachronistic church along the riverside. Mary is the future, the openness to God toward which the prophet longed.

The real encounter, of course, is between the unseen children. John leaps in his mother's womb, drawn into action by the presence of Jesus. Jesus silently makes his mother into an image of what it means to be a Christian, a God-bearer.

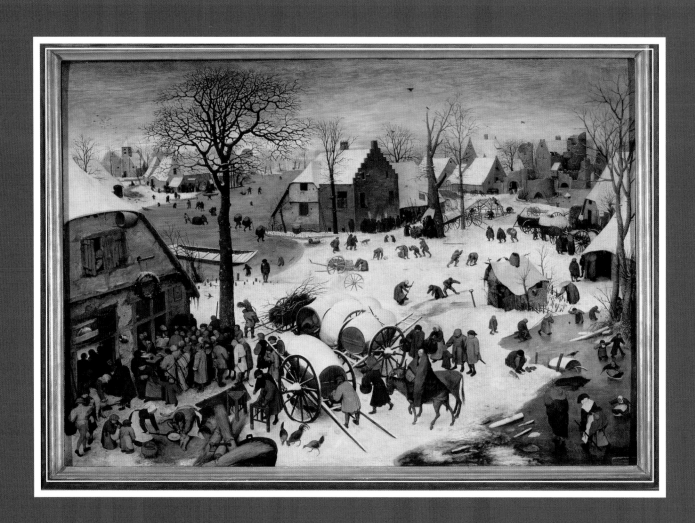

JOURNEY TO BETHLEHEM

The Numbering at Bethlehem, 1566, Pieter Brueghel the Elder
Royal Museums of Fine Arts of Belgium, Brussels

"The time of salvation is at hand." Ideally, the four weeks of Advent are a season of prayer, in which we have the opportunity to look again at the meaning of our life and at how much or how little it is energized by the reality of the incarnation. We have only one life, each of us with our own failures and weaknesses, and the need to receive the transforming grace of Jesus should always be pressing upon us.

Advent calls us to stop and think on this. But for nearly everyone, the season of Advent is also the busiest time of the year. There is so much to be done to prepare for Christmas: cards, presents, the planning of meals, hospitality in general. Leaving aside whether we actually need to do all this, and whether it could not all be simplified, the reality of most lives during Advent is emphatically not one of contemplation. We can benefit from moments that we set aside each day just to keep ourselves grounded in the faith. (It is Jesus and his birth we celebrate, not just togetherness.) But given that there will be much coming and going, much organizing, much activity, can we still enter into the spirit of Advent, this holy season?

The consoling answer is visible in this painting by the great Pieter Brueghel, a sixteenth-century artist who lived in the Netherlands at a time of wretched civil, religious, and military upheaval. He paints Christmas Eve, or at least the run-up to it. Joseph and Mary with, of course, the unborn Jesus, have been summoned to Bethlehem for the census. They have made a long and difficult journey, and they reach the little town to find it packed. Crowds are clustering at the census house, and the very cold weather means that the inhabitants and visitors are storing provisions, wood, and beer.

The casks are definitely beer, not wine, because Brueghel imagines the scene as taking place in his own Flanders. One or two token characters wear Eastern stripes, but nearly everyone is an honest Flanders peasant in contemporary clothes. The buildings are Flemish too, solid brick with a church on the left and a ruined castle (the Spanish had been bombarding) on the right. Children play on the ice and fling snowballs.

Amid this scene of noise and confusion, we see a small donkey, led by a weary man and carrying a young woman. Nobody notices them; nobody pays attention. It is Joseph, anonymous beneath his all-weather headgear, and Mary, looking sweetly and patiently at us. For them, the approach to Christmas is horrendous. Nothing could have been less ideal, and both must have agonized over whether they were letting God down, bringing his Son into the world so little prepared. But their hearts were prepared. Amid the difficult hubbub, they thought only of Jesus. In all this, we can unite with them.

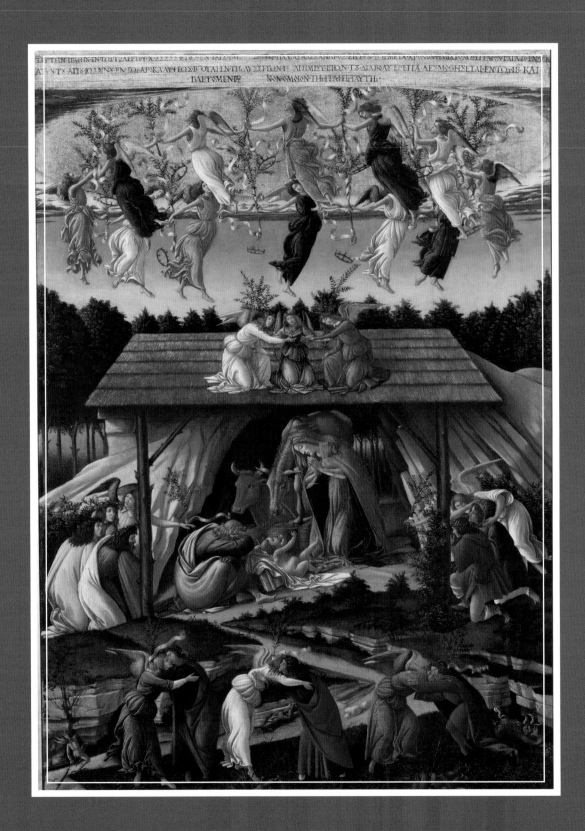

THE MYSTIC NATIVITY

The Mystic Nativity, c. 1500–1501, Sandro Botticelli
The National Gallery, London

The birth of Our Lord is the one feast all the world celebrates, even nonbelievers. We send each other Christmas cards, ideally showing pictures of the Nativity. We erect three-dimensional crèches in our churches, and many people have Nativity scenes in their homes as well. It is a time of togetherness, when family and friends, who may not have seen each other for the past year, meet for the Christmas meal.

Idyllic pictures of the stable, with Mary and Joseph and the child, perfectly reflect this ideal Christmas, this happy and glorious expression of our joy in and gratitude for Christ's coming. In practice, though, the Christmas experience is all too often a tiring and testing time. We may well be exhausted from our preparations, irritated by family foibles (which we have avoided all year), perhaps anxious about expenses, nervously eager to make the day memorable. The shining light of Christmas may reveal an unseemly darkness.

The artist who most beautifully and movingly expresses this is Botticelli, in his *Mystic Nativity*. He had lived through the spiritual awakening that Dominican priest and reformer Savonarola offered to

the people of fifteenth-century Florence: Botticelli's brother was one of the friar's most enthusiastic followers, and he had seen the destruction of Savonarola, by authorities both ecclesiastical and political. I think that *The Mystic Nativity* is an expression of these new and life-changing insights.

In this great painting, we are shown three levels of reality. In the center, larger than life-size, Mary and Joseph are rapt in adoration, while the small Jesus opens his arms in love. On either side cluster the shepherds, brought to the crib by angels. In most Christmas scenes, as in the Gospels themselves, the announcement to the shepherds is enough to send them searching. Botticelli feels, and this may well be something taught him by Savonarola, that human nature needs more than an announcement. Not only do the angels bring the shepherds, but they encourage them, embrace them, crown them with olive wreaths, and urge them forward, an unmistakable reference to the processions Savonarola organized, of which olive branches were a feature.

Even more tellingly, below the crib, from the deep fissures of the earth, creatures of darkness have emerged, those small devils that lurk in every psyche. But this nastiness, which can threaten us all under

the pressure of Christmas, is being driven back and defeated by the activity we see at the bottom of the picture. Three human beings are actively embracing angels, symbolic of all that is good in each of them. Botticelli shows a difference in the distance between each man and his "angel." The man at the far right has to stretch a long way, the man at the far left is already close.

Botticelli, in the gentlest and most beautiful way, is preaching to us. If we are to enter into the wonder of Christmas, we must actively embrace the love that Jesus makes visible. We cannot just go through the motions, going to Mass, giving presents, offering hospitality. Jesus came to save us from ourselves, but we must grasp and use his grace, we must take active steps. If we do, we banish that dark side of all of us that would keep us from walking up the path, which Botticelli clearly paints, and entering into the presence of the newborn Lord.

But the glory of this painting is in the top third, where a ring of angels, holding olive branches, float and dance above the crib. The bright gold of heaven is behind them; they toss crowns to those on earth, and musically, joyfully, in celestial peace and love, celebrate the gift of Jesus, true God and true man.

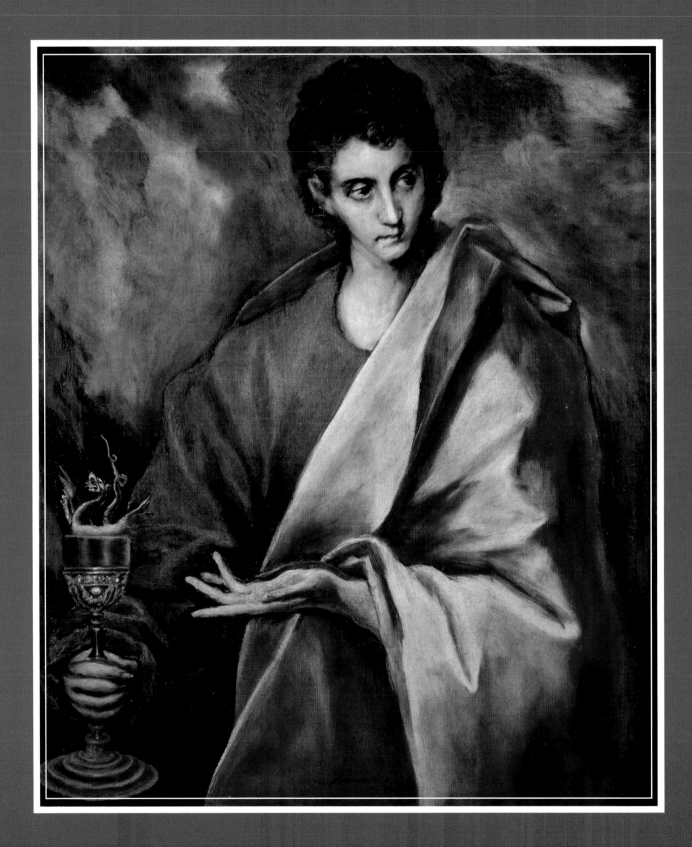

BELOVED DISCIPLE

St. John the Evangelist, 1604, El Greco
Museo del Prado, Madrid

On the day after Christmas, the Church brings us rapidly down to earth. It celebrates the martyrdom of a young man who was not even born at the time of the Nativity. St. Stephen has the glory of having been the first of a countless line of men and women who have laid down their lives willingly for Jesus. But the day after, December 27, we celebrate the one apostle who was not a martyr. It was not that St. John was not as eager and willing as the other eleven. But all attempts to martyr him mysteriously failed.

In this painting by El Greco, he is drawing our attention to a chalice, which, legend tells us, had been poisoned. When St. John took it into his hand the venom within materialized as a sort of ghostly dragon, and he drank the wine without ill effect.

We are also, of course, reminded of the question that Jesus put to John and his brother James: "Can you drink the cup that I shall drink?" When they quickly assured him that indeed they could, Jesus told them that they would drink his cup. St. James, John's elder brother, was to

21

drink it as a martyr. But we can see, in his drawn face with its deeply shadowed eyes and almost unearthly pallor, that St. John was to drink the cup as well, if not physically, then spiritually.

By tradition, John was "the disciple whom Jesus loved." We assume that St. John was relatively young when Jesus died, and had before him years of longing and mourning, bereft of the Lord who had given his life meaning. No one has ever used the time of loss more fruitfully than this young saint. He lived and breathed the meaning of Jesus, contemplating his Lord at ever-greater depth, remembering what Jesus had said and done, seeking to find his full meaning.

We have the result of his contemplative searchings in his Gospel. It stands apart from the other three Gospels, the Synoptics, because of its mystical depths. At the very start—"In the beginning was the Word, and the Word was with God, and the Word was God"—we are led into an understanding of Jesus that could only have come from very deep prayer.

Maybe it was the capacity for this understanding that made Jesus single out St. John as his favorite. The other apostles seem not to have been jealous, but to have recognized that John was somehow special.

El Greco shows him as having suffered, as having become almost immaterial behind the disguise of that immense tunic and cloak. Behind his head loom storm clouds, shot through with light.

If St. Stephen shows us the meaning of faith, a willingness to die for Our Lord, then perhaps it is love that we see emphasized in St. John. But, as all true love, it is not just a personal and private commitment. El Greco shows St. John in a process of communication. His eyes are turned to one side, as he indicates the chalice and silently reveals the impetus of evil. When John took up that poisoned goblet, he had no idea that it was potentially fatal. The evil materialized and vanished, merely at the touch of his hand. St. John is showing that our greatest protection is our closeness to God.

There is much work ahead for this young man. He has his Gospel to write, and there is also the book of Revelation, which tradition has him writing on the island of Patmos. El Greco homes in on the seriousness of St. John's vocation, on his acceptance of his sacred responsibilities. It is impossible not to feel that his extraordinary beauty and presence are the direct result of having known and loved Jesus, the very vocation to which all of us are called.

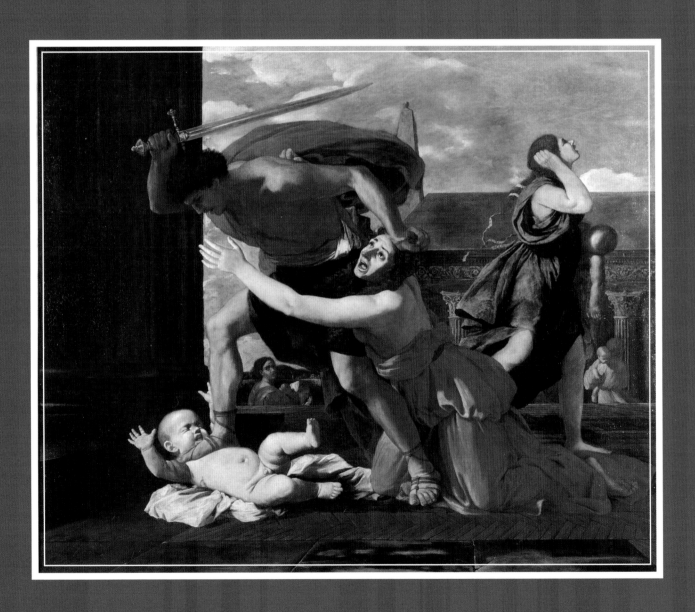

HOLY INNOCENTS

Le Massacre des Innocents, 1628–1629, Nicolas Poussin
Musée Condé, Chantilly, France

Just a few days after Christmas, on December 28, the Church remembers the Holy Innocents. In the liturgy, they are described as proto-martyrs, but this is poetic license. The babies whom Herod slaughtered were too young to be able to choose martyrdom, or, indeed, to refuse it. They were pure victims, and so were their mothers, agonizing not only over the deaths of their children but over their helplessness to protect them. This day is not a celebration but a commemoration of human cruelty, human vulnerability, and the terrible ubiquity of suffering.

Most painters show a crowded canvas where mothers and children and executioners are involved in a vast and terrible confusion. Poussin highlights only the three categories involved in the tragedy. We see the soldier, the man of violence, one hand brutally thrusting back the mother as he wrenches her head away, tugging at her hair. He does not even look at her: She is an excrescence, a nuisance, too weak to be any sort of hindrance. (His arm is brown and sinewy; hers is pale and graceful.) His other hand, lifted high, grasps his sword while one foot presses on the crying child, keeping it in position for the death blow. His other foot tramples the mother's dress, crudely jammed between her knees. Visually, this is a symbolic rape, not of her chastity, but of what is dearest to her heart, her child.

The soldier's face is appropriately shadowed by heavy and authoritative pillars, but a cold, clear light shines full upon the pale horror on the face of the mother, seemingly frozen in a soundless scream. Beneath the power of the upraised sword, and the helplessness of her outstretched arm, lies the child, eyes shut, small legs hopelessly kicking, about to be murdered.

We may try to prettify Christmas, and concentrate—quite understandably—on the joy that Jesus is to us. But, as he was to tell his followers, he came "not to bring peace but a sword." His birth was the crucial event of human history. Will we grow up to the measure of Christ, or will we continue in our pettiness, flaunting the label of Christian but not accepting its profound consequences? As the Gospels make painfully clear, it was because of Jesus that these babies were killed. Obviously, it was not his fault—it was the fault of a ruthless and ambitious man. It was also the fault, we could say, of his employees, who chose to keep their military jobs rather than follow their consciences. (And do we always follow our consciences?)

What the Church is determined that we should recognize is the inescapability of human suffering, and the need to come to terms with the full pain of it. Every parent who has lost a child, whether through sickness or accident or human evil, has entered deeply into the experience that we commemorate as we remember the massacre of the innocents. They will have tasted the bitterness of their own inability to protect and save; they will have known the bewilderment and even sense of betrayal that Poussin shows us so vividly in this mother, and the three grieving mothers in the background.

So many who lose faith, or never accept the truth of Jesus, lay the blame on the mystery of evil. Why, they ask, why? Why? How can God allow this massacre and all the massacres that darken the pages of history? Jesus gives no answer. What he does is come into the world and suffer with us. Even though he escapes this first massacre, he will nevertheless die an equally terrible death thirty-three years later. The Church wants to remind us that among the very first sounds heard by the newborn Jesus were the cries of other babies and the shrieks of their mothers.

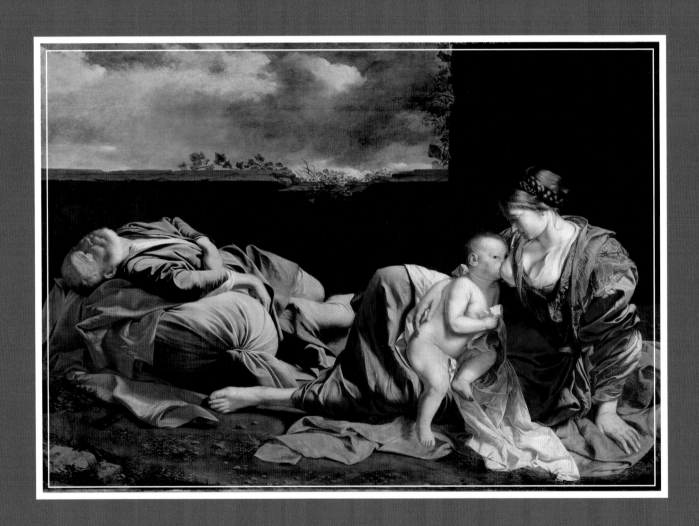

FLIGHT INTO EGYPT

Rest on the Flight into Egypt, 1625–1626, Orazio Gentileschi
Kunsthistorisches Museum, Vienna

The artistic imagination has often been kindled by the flight into Egypt. Usually Our Lady is shown as seated in a meadow, feeding her child with the fruit that St. Joseph is industriously pulling down from the trees. Around them flit small and engaging angels. Or in a more serious mode, we may see Mary on a donkey, orderly and composed, while her faithful Joseph either lingers behind or leads the donkey by its reins.

Both images often show in the background the legendary events the early Church imagined for the flight. There are harvesters questioned by the soldiers Herod has sent to capture Jesus. They are able to tell them quite truthfully that the Holy Family did indeed pass that way, but it was when they were sowing the grain. No need to add that it had miraculously grown to full height in the course of an evening. Meanwhile all the idols, conveniently high, which the Holy Family pass, are immediately toppled. But this is really to make light of what must have been a harrowing experience.

Gentileschi attempts to show the reality of such a hurried journey. Both adults are small-town Jews, running away from an armed pursuer into unknown territory. They have little money. They know nobody in Egypt. All they have is an anguished determination to guard the child that has been entrusted to them. How anxious they must have been, how ashamed by their lack of resources, how profoundly aware of their dependence on God.

The artist shows Joseph as exhausted, slumped uncomfortably in sleep. Physically, we feel, he has at the moment little more to give. He is a drained man. Mary can still sit upright, but only because her child needs her. Both hands are slack with fatigue, and her face seems taut with the strain of their responsibility. She knows, even better than Joseph, who Jesus is and what he means to the world. In this dark little resting place, with only a low stone wall to protect them (that sky looks ominous), only the child is happily unaware, as all babies are, of his parents' vulnerability.

Joseph and Mary had a rocky start to their marriage. He, quite naturally, suspected her of betraying him, both a great sorrow and a scandal. She, on the other hand, must have been wounded that he did not trust her. Then there was the difficult journey to Bethlehem, the astounding events there; and now there is this dangerous crisis. It must have been a time of real growth in marital love for both of them. Each had to trust the other. Only as true partners could they nourish and protect their son.

All relationships go through difficult periods, but God can help us make those very difficulties a source of deeper understanding and love. The example of the Holy Family encourages us to accept the reality of family life, which may at times be painful. They are a source of hope and courage.

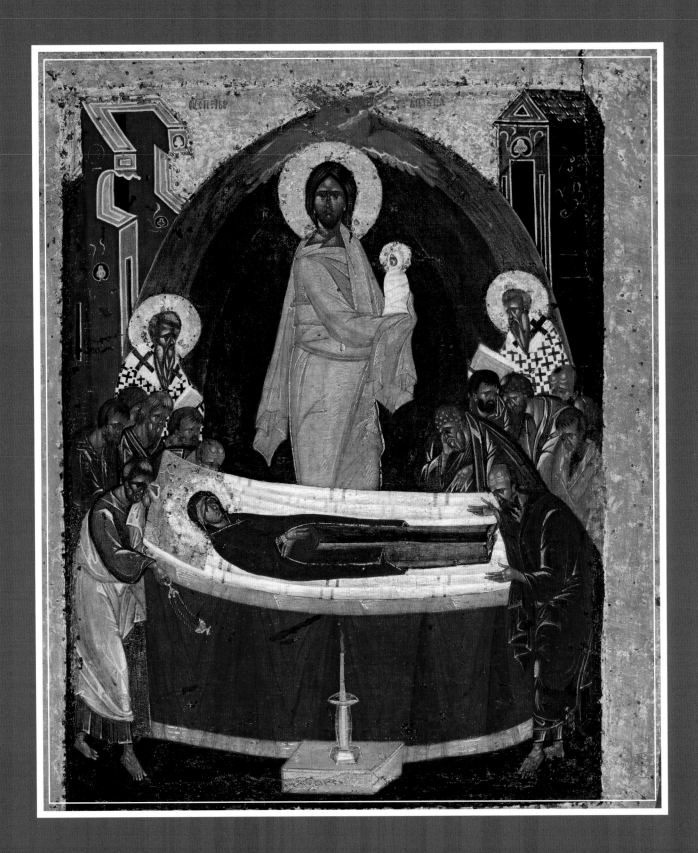

MOTHER OF GOD

The Dormition of the Virgin, 1392, Theophanes the Greek
Tretyakov Gallery, Moscow

New Year's Day has always been celebrated, whether by singing "Auld Lang Syne" on the eve, or by making New Year resolutions on the day itself. But it was not until fairly recently that the Catholic Church named January 1 as the feast day of Mary, Mother of God.

Beginnings are full of hope and challenge, a good time to have the support of our heavenly mother. The ideal mother is essentially supportive, not only giving us life but protecting and encouraging us always. Perhaps no one is as interested in us, as eager to hear of our small triumphs and failures, as our mother. Yet no earthly mother, however cherished, can be to us what Our Lady is. Her protection and love are precisely what we need as we set off into the unknown of our new year.

The Church's New Year feast day, though, is dedicated to Mary, Mother of God. Sometimes we seem to isolate Our Lady from her full truth. All that she is, all her beauty and grace, comes absolutely from one thing only: her relation to her son. Nobody knew this more profoundly than Mary herself. She sang with joy of her "lowliness"; she rejoiced that she could "magnify the Lord" and receive everything from him.

What the Catholic Church celebrates as the Assumption, the Orthodox Church celebrates as the Dormition. In this icon we see Mary, small and frail, laid on her deathbed. Before her burns the candle of intercession, and on either side throng the grieving apostles. Behind them are two of the Orthodox theologians (probably St. Basil and St. Gregory) who wrote with the greatest insight about the death that was no death.

But the meaning of the icon is in the great golden figure of Jesus, dominating the scene, radiantly alive. In his arms, he cradles the soul of Mary, luminous in its purity, assumed into the heaven that is her rightful home. A week ago we celebrated the birth of Jesus, and it was Mary who was the large figure, cradling with love the small figure of her newborn son. Now, at the end of her life, it is her son who cradles her, receiving Mary's as he will receive, one day, our souls too.

What I love about this painting, this icon, is that it gets its priorities so completely right. Mary is great because of Jesus. He is the mediator, he is the sole way to the Father, he is our life and our truth. Mary's

enormous privilege, her uniqueness (William Wordsworth called her "our tainted nature's solitary boast"), was to give birth to Jesus. It was her "yes," her "amen," that made the incarnation possible.

It was Mary who made it possible for Jesus "to grow in wisdom and grace," and in the course of time enter upon his apostolate and his redemptive death. Mary would have seen herself simply as a conduit, the means through which Jesus could become our everything. If we divorce her from this, her vocation, we are not accepting the fullness of her motherhood, her motherhood of God and, through him, her motherhood of us.

If we are to keep those bright New Year resolutions, or even if we are genuinely to remember "auld acquaintance," then we are accepting the totality of our past life and entering, hopefully, upon the new. Neither acceptance is as easy as it may sound. To be true to the past and open to the future is only possible with the grace of God. Mary, the Mother of God, is a constant impetus toward that grace.

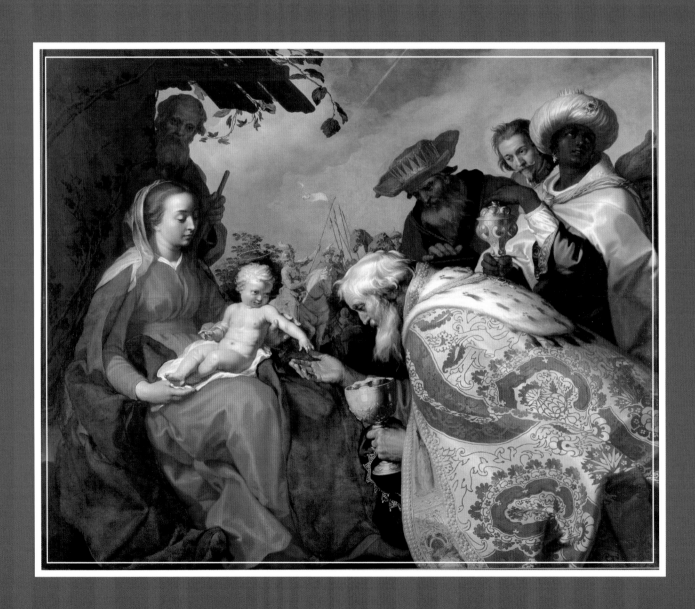

EPIPHANY

The Adoration of the Magi, 1623–1624, Abraham Bloemaert
Musée des Beaux-Arts, Grenoble, France

We regard the Epiphany as the culmination of our Christmas festivities. Jesus has been born. He has been visited by the poor—the shepherds—and now he shows himself to the Magi, the wise men from the east, whom Christian imagination soon transformed into kings. ("The kings of Tarshish and the sea coasts shall pay him tribute," says the psalmist. "The kings of Sheba and Seba shall bring him gifts.") But to the Eastern Church, the Epiphany was Christmas. It is precisely in the manifestation to the Gentiles, representatives of the whole world, that the incarnation becomes operative, as it were. Our Lord has come to change us.

The holy name *Jesus* means "Savior," and we see his salvation visibly at work here, when these distinguished foreigners, scholars and contemplatives, who have "seen the star in the east," finally come to the end of their search. Bloemaert shows the star there in the top middle, pointing to the unlikely place where salvation incarnate awaits those who seek him.

Legend provides the Magi with names as well as regal status: Caspar, Melchior, and Balthasar. To make their role as representatives even plainer, they were given ages and nationalities. There would be an old king from Europe; a middle-aged king from Asia, dark of skin; and a young, black, Nubian king from Africa.

Here they gather, awed. The black king, Caspar, clutching his rich container of incense, is too moved even to look at the child. He turns his eyes away, overcome. The Asian king, Balthasar, waits patiently and prayerfully to make his offering of a closed bag of myrrh. Bloemaert, as is usual in Magi pictures, emphasizes Melchior, the old king with his European looks and his flowing white locks. Of the three gifts to be presented, his is the gold, a great cup gleaming with coins.

But he does not offer it. Instead, beautifully, he offers his empty hand, which the child gently touches. It is Jesus who gives. All the

worldly glory of the Magi is quite unimportant. What matters is to receive, to be detached from wanting material things, and open to accept from God the things of the spirit: Neither Mary, sweetly confident, nor the shy Joseph, peeking round the corner, is in the least concerned with these amazing presents. Their eyes are on Jesus, as he silently communicates to the travelers how they have found their heart's desire.

They are welcomed by Jesus because they want him. They have taken great trouble, come a long way, made sacrifices, just to find him. He is infinitely close to us, but we cannot find him unless we, too, take trouble and search. Jesus will reveal himself to us exactly to the degree that we want him.

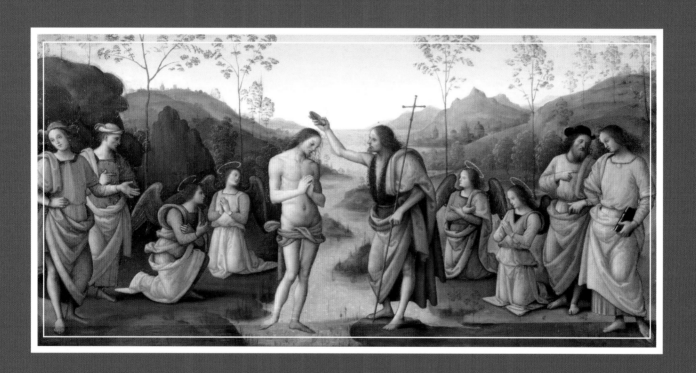

Baptism

The Baptism of Christ, 1482, Pietro Perugino
Sistine Chapel, Vatican City

The essence of Christmas is the showing forth of Christ, so that we understand who he is and what he means, as far as this can be possible. The greatness of God will always elude our full understanding, but we can come ever closer. The Epiphany, the shining forth of what Jesus is, is too great a mystery to be wholly contained by the feast of the Epiphany.

The Church expands that feast to include Jesus's baptism. Of course, this is an adult Jesus, but it is an astonishing unfolding of his true identity. It is a mysterious event. What was in the mind of Jesus when he came to the River Jordan, when John the Baptist was preaching repentance and inviting his listeners to enter the river for a baptism of repentance?

The act symbolizes a conversion, a turning away from sin to God. Jesus had no sin. He had loved his heavenly Father all his life and done always the things that pleased him. Was he entering into the act of contrition for our sakes, to express the repentance he longed to teach us?

Notice how completely indifferent Our Lord is to what people might think of him. Let the bystanders judge that he must be a sinner since he needs to do this. Jesus knows why he acts and his Father knows. He wants nothing else.

Some artists throng their depiction of this scene with converts undressing to receive their symbolic baptism, and Pharisees muttering in irritation at the spectacle. But Perugino feels that for Jesus, and John too, it is a moment of deepest privacy, with few but the unseen angels in attendance. The angels are lost in adoration, because what is happening is the most momentous of epiphanies. The Gospels tell us that God the Father reveals himself, speaks from heaven, and the Holy Spirit is visible as a dove. The picture does not show the unimaginable. There is only a faint glow in the sky to remind us of the revelation.

The words that the Father speaks call Jesus "my beloved Son, in whom I am well pleased." In the Gospels of Mark and Luke, the words are addressed directly to Jesus: "You are my beloved Son." Can it be

that this was the first explicit manifestation to Our Lord himself of exactly what he was in relation to the Father? That his Father filled his life and gave it meaning, he knew. At twelve years old he could refer to the Temple in Jerusalem as his Father's house and be taken aback to discover his mother had looked for him "everywhere" and thought him lost.

But these words at the baptism are a solemn proclamation. They are made aloud and the Holy Spirit who overshadowed his conception appears again. Jesus must have felt, clearly and forcibly, for the first time what his role was, and the sacred responsibility. As Son he must teach his brothers and sisters about the Father.

Perugino shows John as diffidently pouring the baptismal water, but Jesus seems aware only of that inner certainty that has drawn him into a profound peace. He is intent only on the beloved Father, and conscious only of him, responding utterly to this realization of his apostolic mission.

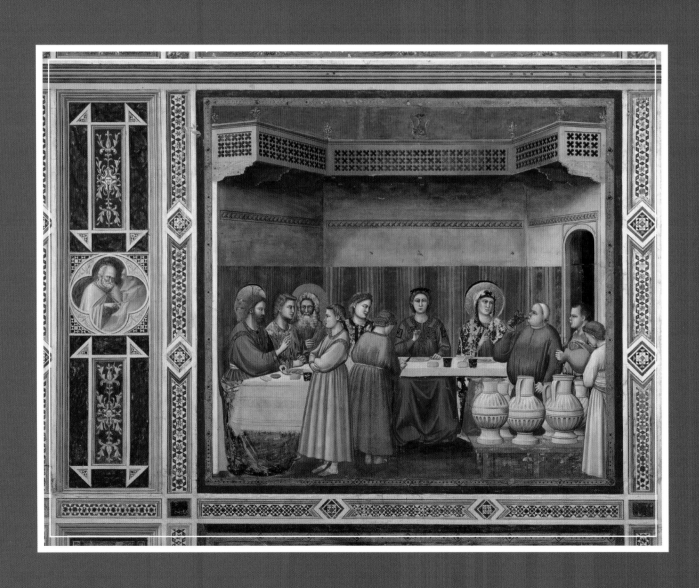

WEDDING AT CANA

Marriage at Cana, 1304–1306, Giotto
Scrovegni Chapel, Padua

The third Epiphany feast is the wedding feast at Cana. Of course, anything that Jesus did and said revealed him. But St. John tells us that this was the first of the miracles, the first time that Jesus displayed that awesome ability to transform material reality and make it signify something greater than itself.

It is an event overflowing with symbolism, yet the setting could not be more ordinary. There are several episodes in the wedding feast story, and artists have to decide which to depict. Giotto begins mid-event. Mary, sitting on the right of the table, has already noticed that the wine has run out and the hosts are soon to be embarrassed. Fortunately, Giotto paints the table as a medieval feast, with people sitting only on one side. Later depictions can appear confused, with a profusion of guests, but here we see few.

Mary has whispered to Jesus that something needs to be done. He has told her that this is not the time (or place?) for an epiphany. Was Jesus reluctant to move out of the privacy of his prayer relationship with the Father and make public his divine Sonship?

Giotto shows us Mary's reaction to his refusal. She is telling the servants: "Do whatever he tells you." These are words of infinite depth, the essence of what Our Lord says to each of us always. We are asked to look at Jesus and listen to him. Whatever he commands, that will be life for us.

The artist depicts the next stages in the following of this motherly advice. Jesus is instructing the servant to fill with water the six huge water pots lining the table. The young waiter looks rather perplexed. These water pots were extremely large, containing twenty gallons, says St. John, but another detail on the far right sees a servant doggedly pouring in water.

The next stage, the result, is in mid-action. The steward, whose rotundity tells us he does quite a bit of tasting at feasts, has drawn a beaker and is tasting the miraculous water-turned-wine. Soon he will

comment, in astonishment, that usually the good wine is served first, then the poor, but here the best wine has been kept for the last.

The astonishing thing about this manifestation, this epiphany, is that it goes almost unnoticed. The groom, the bride, and the bridesmaid are oblivious both to the humiliation approaching and to its miraculous disappearance. On this lowly level, they have been "saved," yet they are unaware. Only the apostles realize that the world has changed.

Giotto shows us only one apostle, probably St. Peter, who is awed, almost terrified. After this, the apostles knew who Jesus was, but they knew because they noticed. All day Jesus is revealing himself to us, but the circumstances are human. We are distracted by the inessential, and so we miss the whole meaning; we taste the wine, but we do not understand its significance.

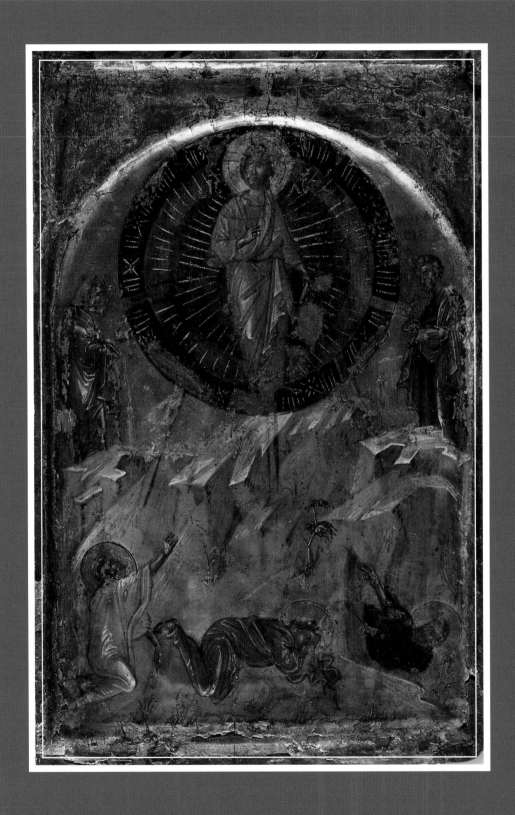

TRANSFIGURATION

The Transfiguration of Christ, 1310–1320, detail from a
Byzantine icon
British Museum, London

When the Magi saw Jesus they saw a baby, with only a star to support their faith in his divinity. When John saw Jesus and baptized him in the Jordan, he saw a young man, and it was the voice from heaven proclaiming him beloved Son that enabled him to believe. The apostles at the marriage feast of Cana also saw only a fellow man, and they were enlightened by no heavenly voice. They believed that this was "the Christ, the Son of God" because of the miracle they were privileged to share.

It is different at the transfiguration. Peter, James, and John have come with Jesus to a high mountain, where he loses himself in prayer. He is still, in their eyes, the same Jesus. Intellectually they have accepted that he is the Son of God, but as the passion story will show, their faith is far from absolute.

Now, though, as they look up at him, perhaps wistfully longing that their own prayer could be so all-absorbing, Jesus changes before their eyes. He becomes radiant with a light so intense that they fall back, dazzled and overcome. His Godhead has, as it were, manifested itself visibly. Jesus has become a blaze of holy light. In the glory of this radiance, they realize that he is talking to the two great figures of the Old Testament, since with God there is no time and no death. On one side is Elijah, the embodiment of the prophets, what we might call the poetry of loving God; and on the other is Moses, the lawgiver, who spells out the practicalities.

In this wonderful icon, all three apostles are in a state of ecstasy. James, on the right, is falling down the hill in his joyful abandon. John, in the middle, sinks overwhelmed to the ground. Only Peter, on the left, can still speak. He lifts up yearning arms to his God, praying to have the blessed moment prolonged: "Let us build here three tabernacles: one for you, one for Moses, and one for Elijah." His stammering plea is silenced by the heavenly voice John the Baptist heard: "This is my

Son, the Beloved." And now the Father adds: "Listen to him!" When the apostles can once again take in what is happening, they see "no one...but only Jesus," the long-known Jesus, whom they proclaimed as Lord in faith—solely in faith.

This shows the reality of Jesus as we do not see it. For just those few moments, three of the apostles did see it, and it was too much for them. The Old Testament tells us that nobody can see God and live. The great significance of the incarnation is that in it we human beings do see God, and live, because God showed himself as man. But it is the same God, the unbearably Holy One.

This icon has Our Lord surrounded by a great circle of darkness, which is the only way we can "see" him. His light is too strong, though we may, with Peter, long to have it and have our unbelief changed into belief. "Lord, I believe; help my unbelief," says a despairing man to Jesus as he leaves the mountain.

We do not need another revelation: We have it in Jesus's birth, life, and death. If we did need it, Jesus would give it. We think, with Peter, that we want more. Yet they saw "only Jesus" and that was enough.

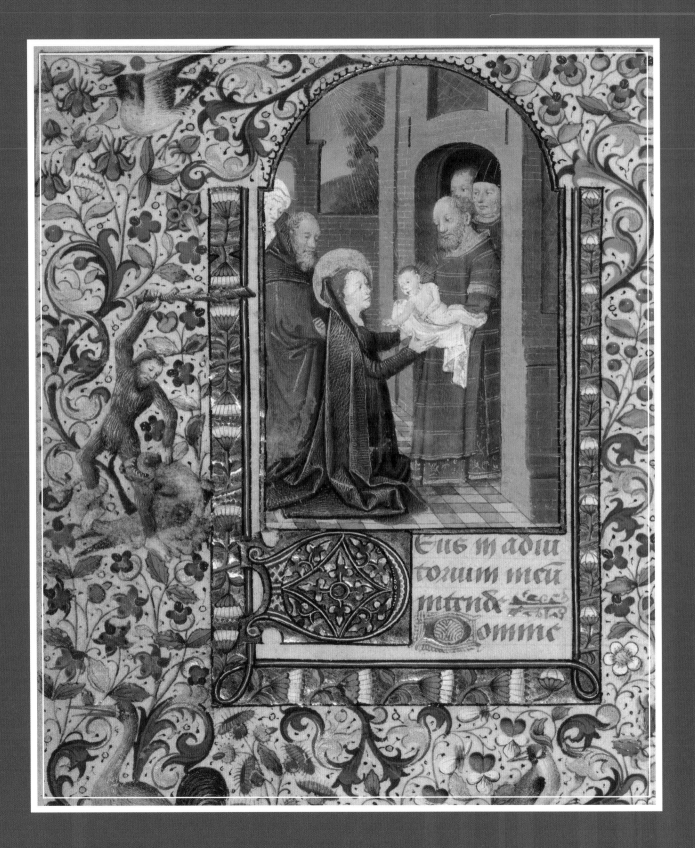

PRESENTATION OF JESUS IN THE TEMPLE

The Presentation in the Temple, 1465–1470, Rivoire Book of Hours
Bibliothèque Nationale de France, Paris

After the four weeks of Advent preparation, the extended Christmas season stretches out gently to the Feast of the Presentation of the Lord. There it ends. Soon it will be time for Lent, and that passion and resurrection toward which the child Jesus has been steadily moving. It is a quiet feast, a symbol of the recognition shared by Mary and Joseph that Jesus is not "theirs." But he is still their responsibility, and will be for several years. It is they who bring him to the Temple, and lay him in the arms of the old priest Simeon. Behind Joseph we can dimly make out the other person who understood who Jesus was, the saintly old woman, Anna.

For Simeon and Anna, this unexpected encounter is transformational. Both represent the Old Testament; even more, they stand as images of all the world of praying, earnest men and women who have longed for salvation, who have been certain there is something more, something beyond them. As Jews, Simeon and Anna have been privileged. They have known with conviction that the Christ would surely one day come, and come to his Temple in Jerusalem. Probably they imagined a grand procession, with the Lord Christ riding victorious at the head. And how does he come? As a baby, the child of a poor mother, with an elderly husband to support her.

The genuineness of their faith is shown in that both Simeon and Anna know immediately that the longing of the centuries is over. Simeon had been promised in prayer that he would not die before he saw the Lord. Now he sees him and holds him. He knows, too, that this salvation, this beautiful and holy light, is "for all the nations," though it has come through the chosen people.

Anna does not seem to have had Simeon's promise from the Holy Spirit of not dying till the Messiah came. Perhaps her faith was so strong she did not need it. But at the mere sight of the child, she believes, asking no proof, and begins to tell her companions that redemption is at hand.

This simple little picture comes from an illuminated manuscript. Books of hours were popular in medieval Europe. They supplied the prayers of the shorter canonical hours, the times in the day when nuns and monks said the Divine Office (the psalms, hymns, and prayers

with which God is praised eight times a day). This painting, this illumination, is from the *Hours of the Virgin,* and some well-to-do man or woman would have prayed from it several times a day, trying to keep his or her heart fixed on God. It is what we want that matters, what we choose. In saying these hours, people were expressing their choice of God.

The delicate little painting shows Simeon, whose face is shining with peace, handing Jesus back to his mother. She receives him with reverence and tenderness. Behind Simeon, filling the door to the Temple, the "Church," are the lay people who have commissioned the book, associating themselves with the Holy Family. All aound the central picture is a rich margin, alive with strange flowers and a fantastic, wild man in combat. It is as if to emphasize that none of us lives apart from confusion; all this happens in a bewildering and active world. But it happens. It is for us to respond to it.

ABOUT THE AUTHOR

Sister Wendy Beckett is an English hermit and art expert. In the 1990s, she was featured in a BBC documentary series on art history. Beckett entered the Sisters of Notre Dame de Namur in 1946 and graduated from Oxford University in 1953. She now lives under the protection of the Carmelite nuns at their monastery at Quidenham, Norfolk, where she leads a life of solitude and prayer, allotting two hours of work each day to earn her living.